Pendants

LARK STUDIO SERIES

LARK CRAFTS
A Division of
Sterling Publishing Co., Inc.
New York / London

Lark studio series: Pendants / [senior editor, Ray Hemachandra]. – 1st ed.
 p. cm. – (Lark studio series)
 Includes index.
 ISBN 9781600596841 (pbk. : alk. paper)
 1. Jewelry making. 2. Pendants (Jewelry) I. Hemachandra, Ray. II. Lark Books.
 TT212.P454 2010
 739.27–dc22

 2010004949

SENIOR EDITOR
Ray Hemachandra

EDITORS
Julie Hale
Larry Shea

ART DIRECTOR
Chris Bryant

LAYOUT
Skip Wade

COVER DESIGNER
Chris Bryant

10 9 8 7 6 5 4 3 2 1

First Edition

Published by Lark Books, A Division of
Sterling Publishing Co., Inc.
387 Park Avenue Sou

Text © 2010, Lark Bo
The pendants in this
and Elizabeth Shyper

Photography © 2010

Distributed in Canad
c/o Canadian Manda
Toronto, Ontario, Car

Distributed in the Un
Castle Place, 166 Hig

Distributed in Austra
P.O. Box 704, Windso

FRONT COVER
Carol Windsor
*AZURE BLOSSOM
PENDANT*
PHOTO BY HAP SAKWA

BACK COVER
Lindsey Mann
*THREE LEAF
PROPELLER PENDANTS*
PHOTO BY HELEN GELL

If you have questions or comments about this book, please contact:
LARK CRAFTS | 67 Broadway | Asheville, NC 28801 | 828-253-0467

Manufactured in China

ISBN 13: 978-1-60059-684-1

For information about special sales, contact the Sterling Special Sales Department at
800-805-5489 or **specialsales@sterlingpub.com**.

Coventry City Council	
CEN	
3 8002 01739 401 8	
Askews	Nov-2010
739.27	£8.99

CONTENTS

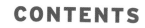

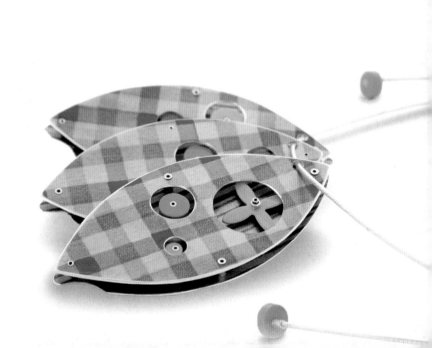

INTRODUCTION

The Lark Studio Series is designed to give you an insider's look at some of the most exciting work being made by artists today. The pendants we've selected are provocative, fun, inspiring, exquisitely made, or simply knockout gorgeous pieces from the world's leading jewelers. Flip through these pages to survey the collection, and then go back and savor each pendant for its creativity, innovation, and fine craftsmanship.

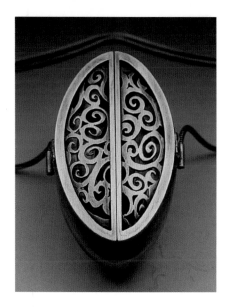

Chris Irick

PASSAGE
7.5 x 6 x 6 cm

Sterling silver; fabricated, die formed, soldered, pierced

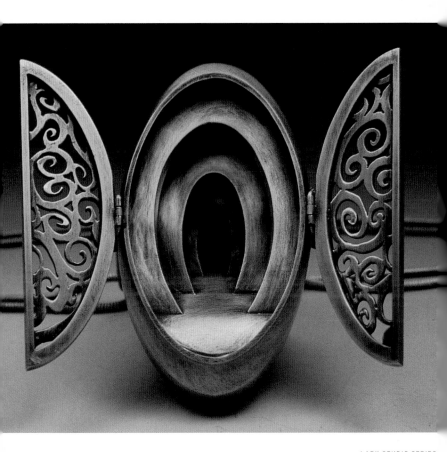

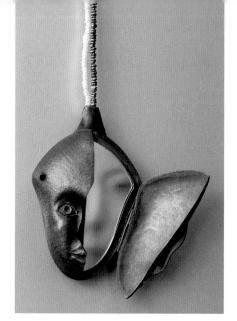

Min-Jung Cho

HALF & HALF
79.5 x 6.5 x 2.5 cm

Copper, pearl, plastic mirror, magnet,
patina; pressed, chased, fabricated

PHOTOS BY KC STUDIO

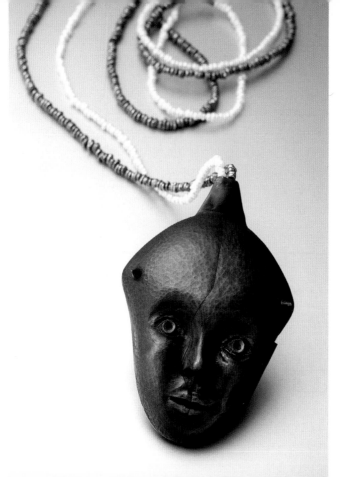

Kevin R. Hughes

ROOM 217
6.4 x 6.4 x 0.1 cm

Brass, steel; fabricated

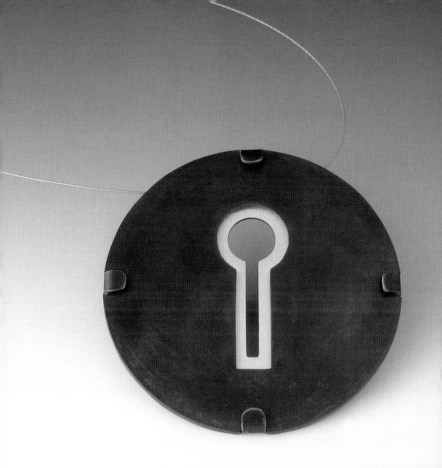

Jessica Calderwood

SLEEPING BEAUTIES
5 x 6 x 0.5 cm

Enamel, copper, 18-karat gold, brass, sterling silver, stainless steel

PHOTO BY ARTIST
COURTESY OF THE DAVID COLLECTION, POUND RIDGE, NEW YORK

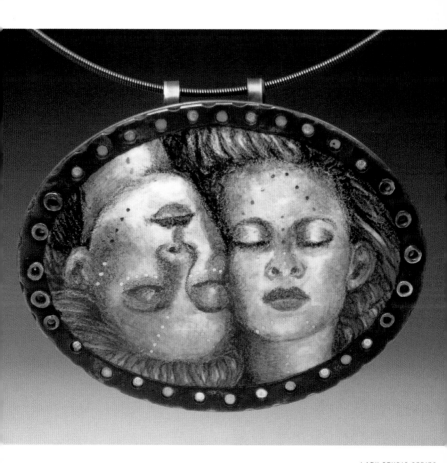

Daniel Jocz

CHERRY SOLITAIRE
5.7 x 2.2 x 2.2 cm

Enamel, copper, 18-karat gold; repoussé

PHOTO BY DEAN POWELL

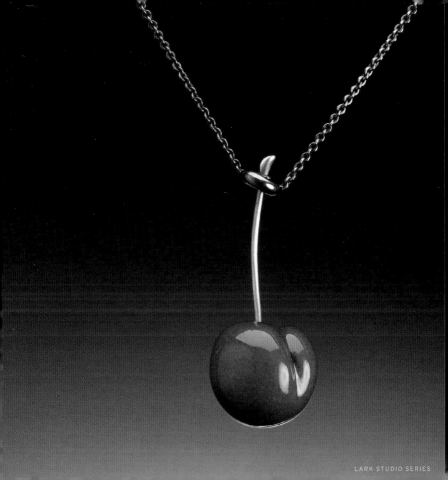

Jiro Kamata

SUNNY PENDANT
7.5 x 7.5 x 1.5 cm

Plastic lenses, silver; laser carved

PHOTO BY ARTIST

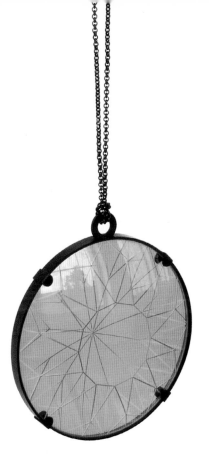

Adrean Bloomard

OPLONTIS COLLECTION-OP3029

Each pendant, 4.5 cm in diameter

18-karat gold, crushed lapis lazuli; constructed

PHOTO BY FILIPPO VIRARDI
COURTESY OF ALTERNATIVES GALLERY, ROME, ITALY

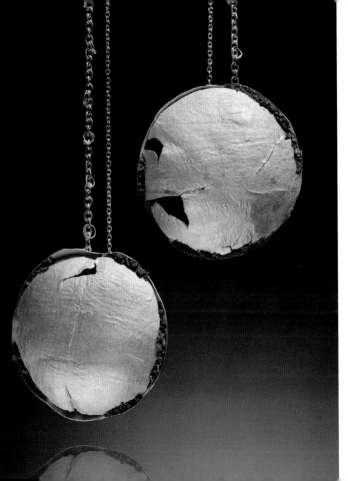

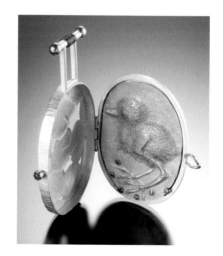

Linda Kindler Priest

BABY LILY TROTTER
6.5 x 3.5 x 0.8 cm

Ruby, 14-karat gold, silk thread,
pearls, diamonds; set, repoussé

PHOTOS BY GORDON BERNSTEIN

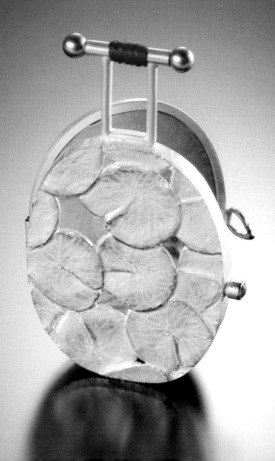

Silvia Walz

BLUE VIEW
5 x 6 x 0.5 cm

Copper, silver, enamel

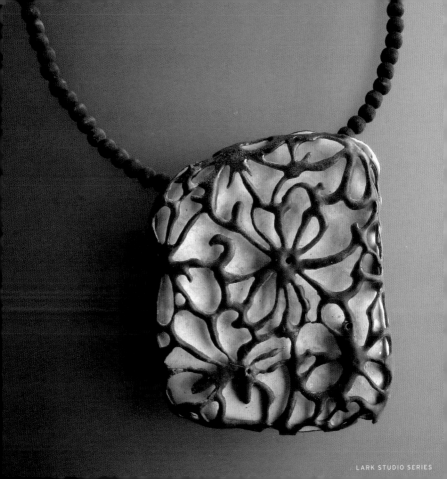

Abrasha

VERTICAL CO$_2$ CARTRIDGE PENDANT-LOCKET
8.7 x 2.8 x 1.9 cm

Recycled CO$_2$ cartridges, sterling silver, 18-karat gold, 24-karat gold; fabricated, cut, filed, sanded, chrome plated

PHOTO BY RONNIE TSAI

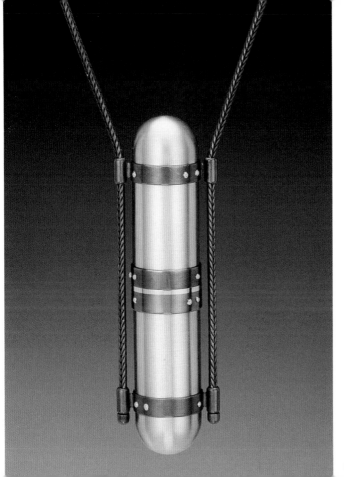

Shin-Lyoung Kim

PLACEBO EFFECT
7 x 2 x 2 cm

Sterling silver, nickel copper; inlaid

PHOTO BY MYUNG-WOOK HUH, MUNCH STUDIO

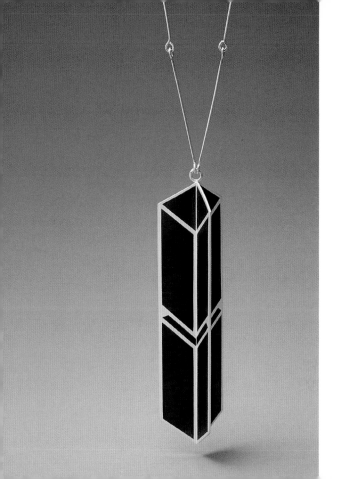

Claude Chavent

CAGE

6.7 x 5.5 x 0.5 cm

Platinum, 18-karat gold; trompe l'oeil

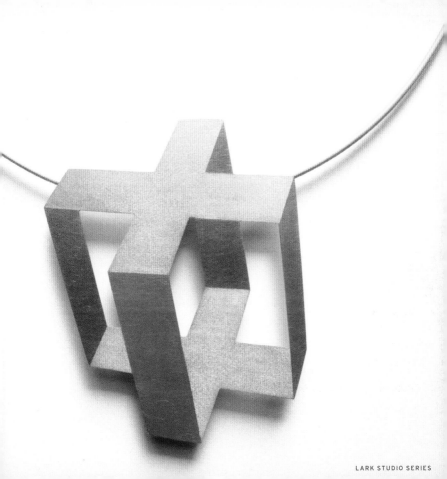

Anne Holman

INHERITANCE

5 x 2 x 2 cm

Sterling silver, stainless steel, glass, antique maps, soil (collected from 30 locations); hand fabricated, soldered, stamped, labeled

PHOTO BY ARTIST

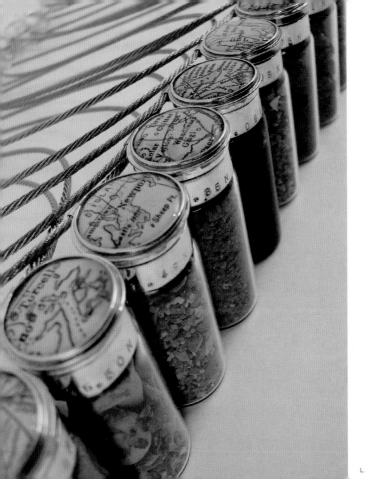

Anne Hiddema

CINQUE

6 x 6 x 3.5 cm

Brass, fishing buoy; fabricated

PHOTO BY PHIL CARRIZZI

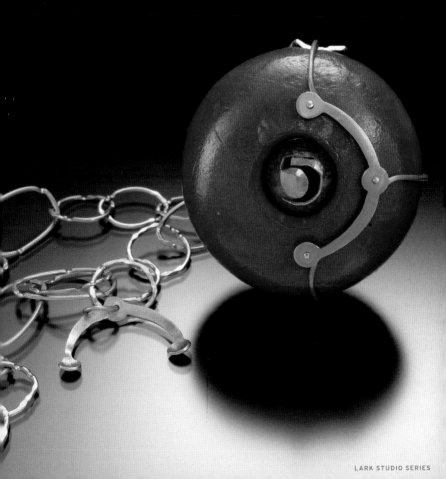

Sonia Morel

UNTITLED
8.5 x 9.5 x 3 cm

Silver, polyester thread

PHOTOS BY THIERRY ZUFFEREY

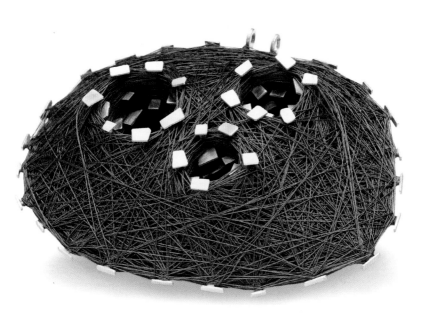

Castello Hansen

UNTITLED

7.5 x 4.5 cm

Cibatool, paint, silver, silk; oxidized

PHOTO BY SØREN NIELSEN
COURTESY OF DRUD & KØPPE GALLERY, COPENHAGEN, DENMARK

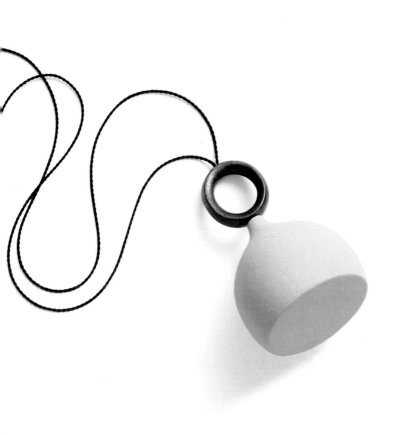

Jeffrey Lloyd Dever

AUTUMN'S PROMISE

7 x 6.3 x 1.3 cm

Polymer clay, anodized niobium cable;
hollow-form constructed, drilled, back filled

PHOTO BY GREGORY R. STALEY

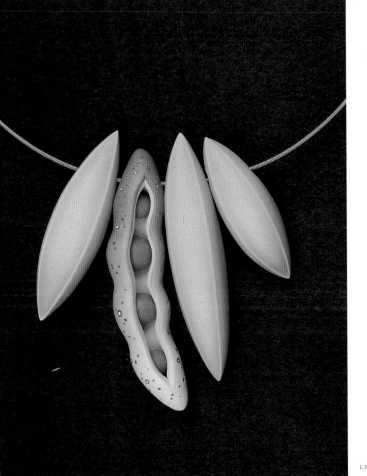

Jan Smith

UNTITLED
12 x 6.5 x 1 cm

Sterling silver, copper, enamel, felt, silk, thread, pearls, graphite

PHOTO BY DOUG YAPLE
COURTESY OF VELVET DA VINCI GALLERY, SAN FRANCISCO, CALIFORNIA

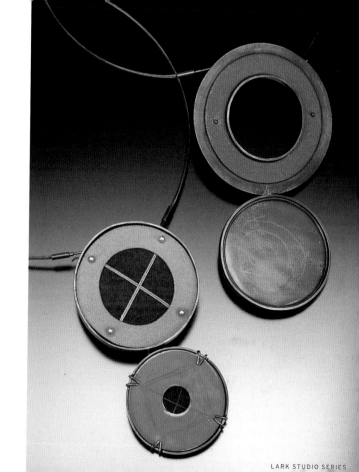

Lindsey Mann

THREE LEAF PROPELLER PENDANTS
Each: 8 x 5 x 0.5 cm

Anodized aluminum, silver, plastic; printed, strung

PHOTO BY HELEN GELL

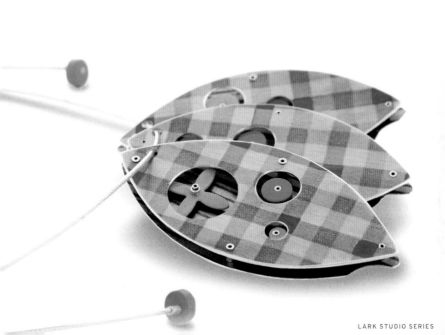

Karen McCreary

GEODE PENDANT
12 x 2.5 x 1.5 cm

Acrylic, 22-karat gold leaf, sterling
silver; carved, hand fabricated

PHOTO BY ARTIST

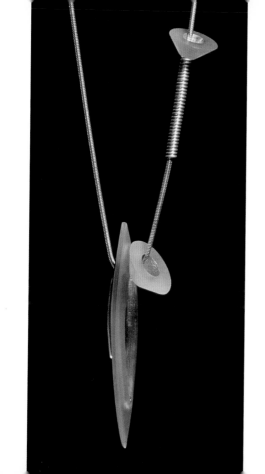

Silke Trekel

JO-JO
7 cm in diameter

Silver, stainless steel; hammered

PHOTO BY CHRISTOPH SANDIG

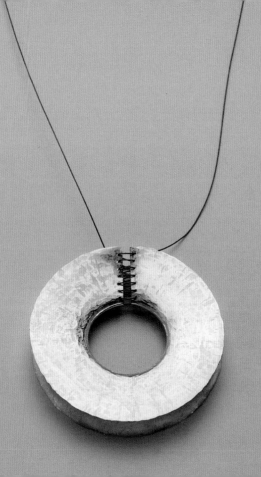

Shana Astrachan

WHITE DIAMOND PENDANT
10.2 x 5.7 cm

PVC sequins, sterling silver

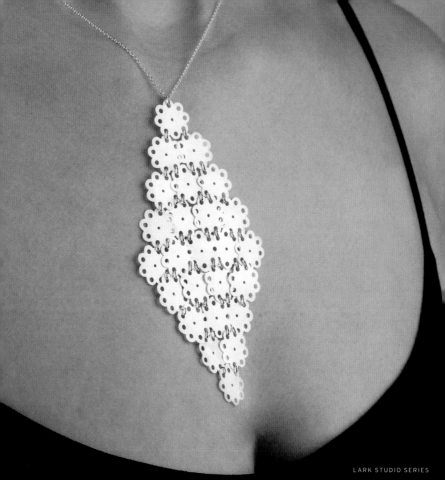

Susan May

MEMENTO
82 x 6 x 1.5 cm

Sterling silver; forged, hollowed, fused

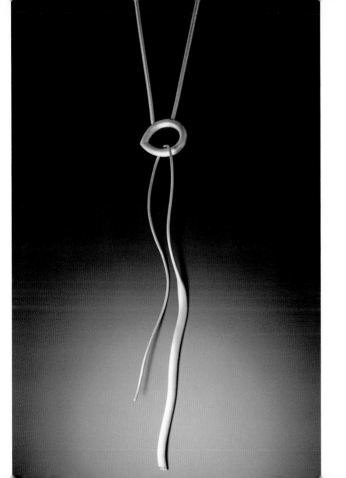

Mark Rooker

KLEPTOPHILUS ORNAMENTUM

3.8 x 4.2 x 2.2 cm

14-karat yellow gold, sterling silver, niobium,
yellow brass, pearls; fabricated, carved

PHOTO BY ARTIST

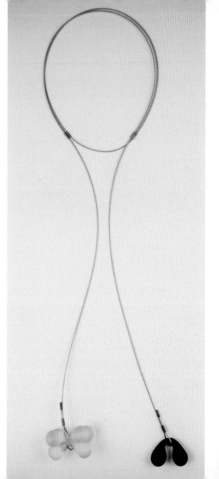

Caroline Gore

OFF
60 x 21 x 7 cm

Borosilicate glass, stainless
steel, sterling silver

PHOTOS BY ARTIST

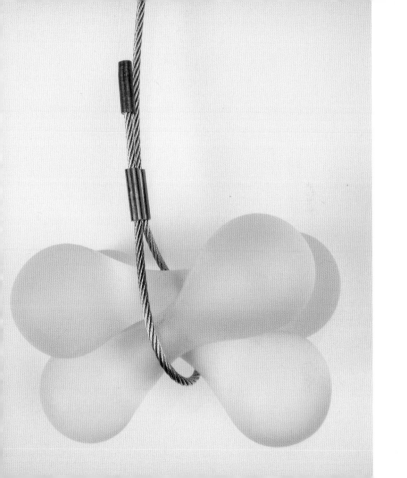

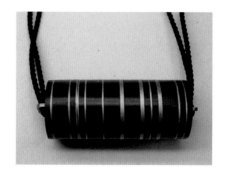

Min Kyung Kim

THE KNIFE
4.5 x 12 x 4.5 cm

Brass, acrylic; fabricated

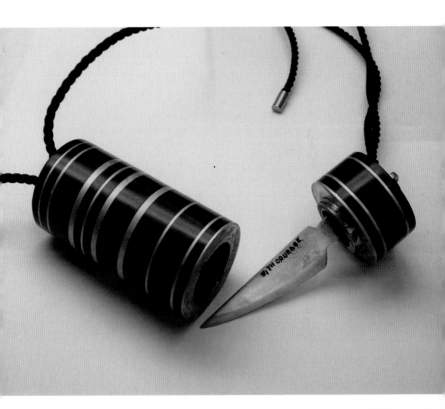

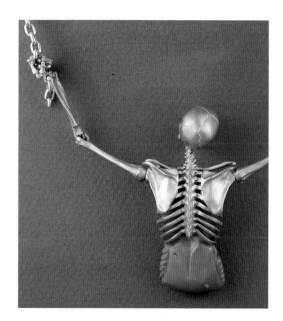

Kim Eric Lilot

EPIPHANY
5.7 x 8.5 x 1.2 cm

14-karat white gold, coral, carved rubellite tourmaline heart;
fabricated, ball and socket joined, lost wax cast

PHOTOS BY ARTIST

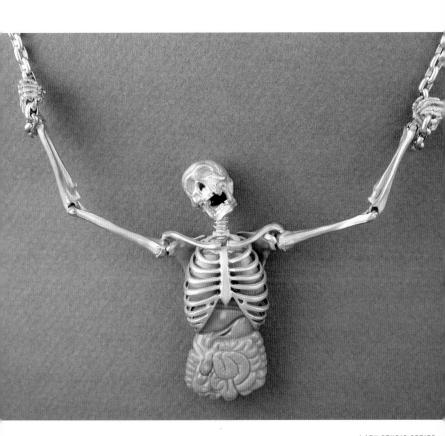

Susan Skoczen

PINK & BLACK NECKLACE

5 x 4 x 3.3 cm

Sterling silver, acrylic paint, oil paint; flocked, oxidized

PHOTO BY DAN FOX, LUMINA
COURTESY OF VELVET DA VINCI GALLERY, SAN FRANCISCO, CALIFORNIA

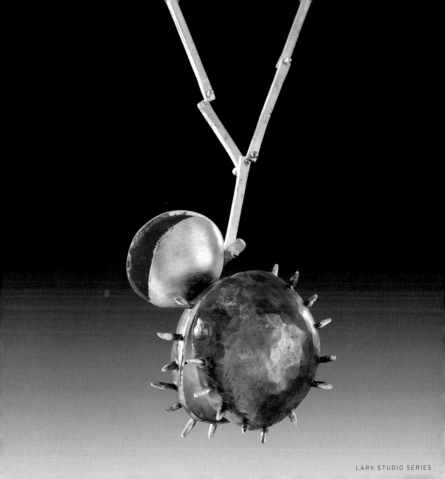

Suzanne Beautyman

WORKING WITH DAD
32 x 15 x 2 cm

Shibuishi, iron, 18-karat gold, silk

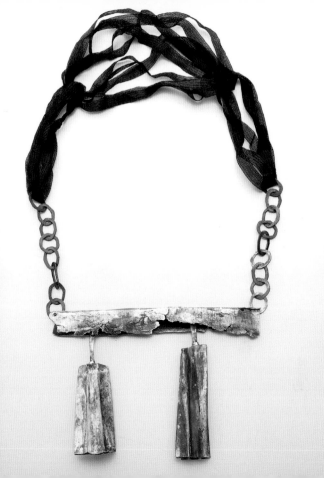

Donna D'Aquino

NECKPIECE #3
9.5 x 8 x 0.5 cm

Steel, 18-karat gold, PVC; hand fabricated

PHOTO BY RALPH GABRINER

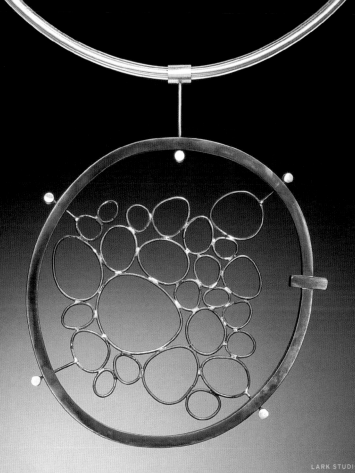

Kathryn Wardill

BRANCH AND GLASS CLUSTER PENDANT-GREEN

2.5 x 1.2 x 0.4 cm

Glass, sterling silver, metal clay; lampworked

PHOTO BY ARTIST

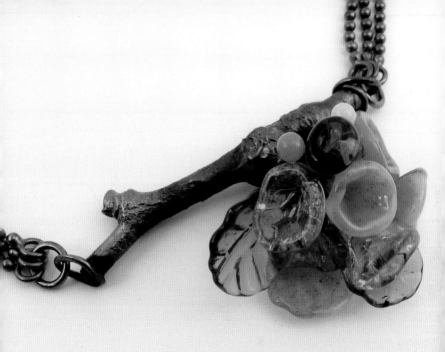

Beppe Kessler

HERITAGE

5 x 2 x 2 cm

Gold, silver, alabaster, balsa wood, cotton

PHOTO BY ARTIST

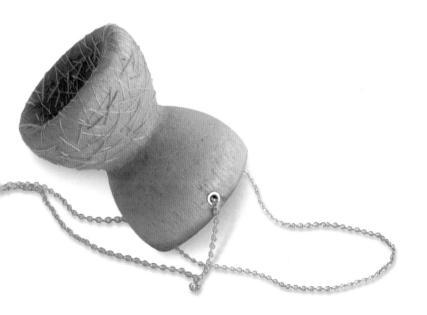

Diana Dudek

UNTITLED
1.5 x 8 x 1.5 cm

Silver, textile, hematite

PHOTO BY ARTIST

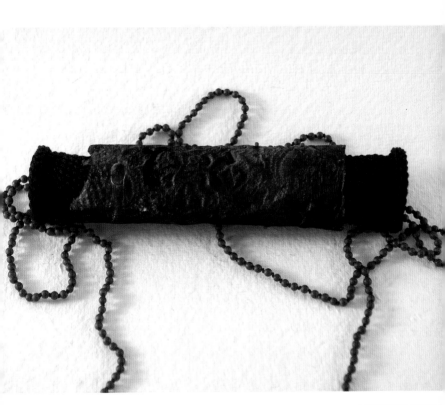

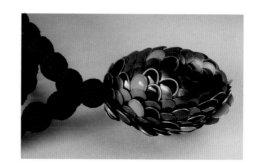

Yael Krakowski

EMU PENDANT
5 x 3 x 3 cm

Silver, enamel, polyester thread; oxidized, crocheted

PHOTOS BY ARTIST
COURTESY OF CHARON KRANSEN ARTS, NEW YORK, NEW YORK

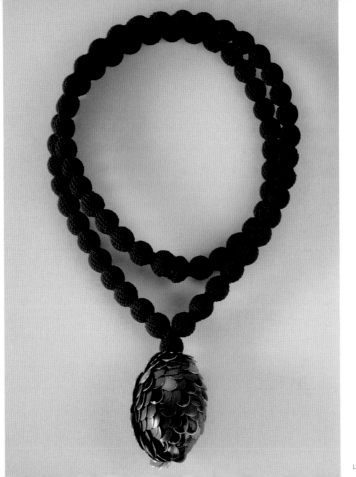

Fabiana Gadano

TELARES PENDANT
7 x 3 x 0.4 cm

Sterling silver; constructed

PHOTO BY PATRICIO C. GATTI

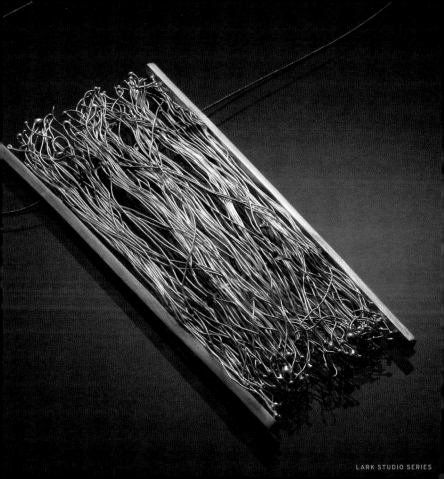

Yoko Shimizu

UNTITLED
6 x 6 x 0.5 cm

Silver, gold; niello

PHOTO BY FEDERICO CAVICCHIOLI

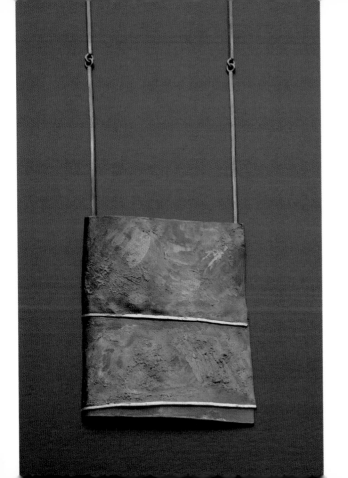

Lorena Lazard

HEART TO BE FILLED
3.5 x 3.1 x 1.7 cm

Sterling silver, shibuishi, copper, acrylic paint; fabricated

PHOTO BY PAOLO GORI

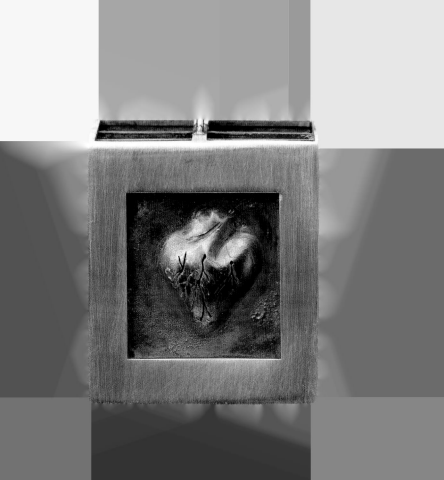

Mike Holmes

RED PENDANT
7 x 4 x 1.3 cm

Enamel, patina, copper, sterling silver; fabricated

PHOTO BY ARTIST
COURTESY OF VELVET DA VINCI GALLERY, SAN FRANCISCO, CALIFORNIA

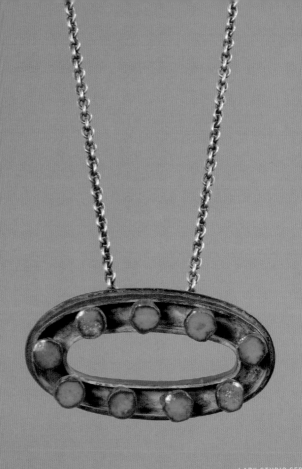

Valerie Mitchell

DROP ROOT UNDULOID PENDANT

15 x 3 x 3 cm

Enamel, copper, sterling silver; high fired, hollow formed,
electroformed, hand connected, oxidized

PHOTO BY RALPH GABRINER

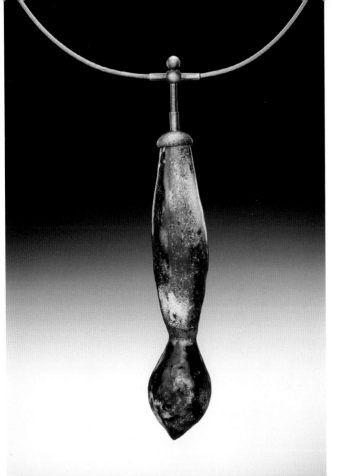

Jin-Ah Jung

A DOT OF ILLUSION
17.8 x 4.2 x 0.8 cm

Sterling silver, clay, paint; hand fabricated

PHOTO BY MYUNG-WOOK HUH

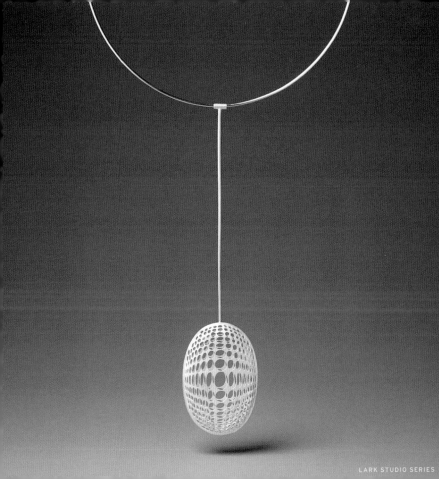

Sandra Enterline

CAPSULE PENDANT

3.8 x 2.5 x 2.5 cm

18-karat yellow gold, sterling silver; fabricated, hand drilled

PHOTO BY MARK JOHANN

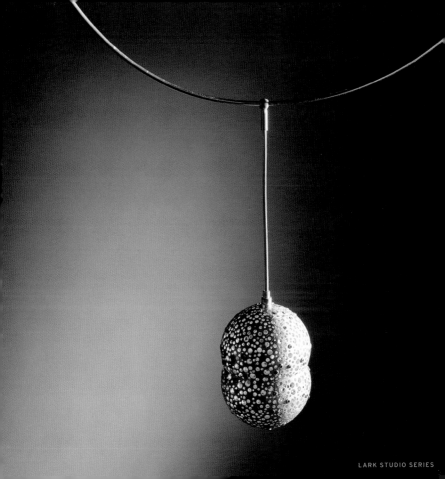

Suzanne Esser

UNTITLED
7 cm in diameter

Wood, red coral, chain; silver; lathe turned

PHOTO BY RON ZŸLSTRA

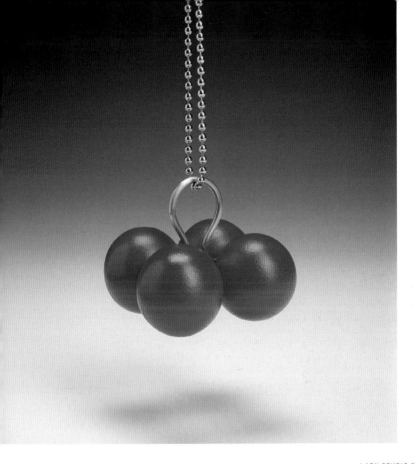

Cornelia Sautter

UNTITLED

9 x 4 cm

Synthetic materials, textile, gemstone beads

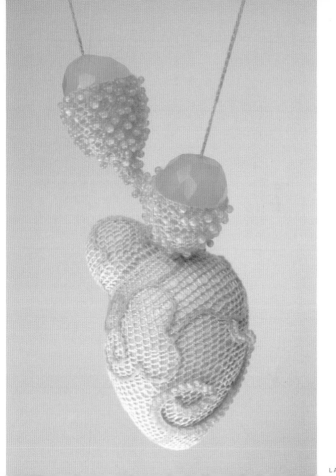

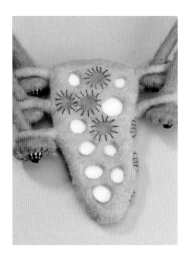

Lisa Klakulak

UNTITLED

25.4 x 15.2 x 2.5 cm

Wool fleece, glass seed beads, thread;
 dyed, wet felted, hand stitched, beaded

COLD-WORKED BLOWN GLASS BY ETHAN STERN
PHOTOS BY STEVE MANN

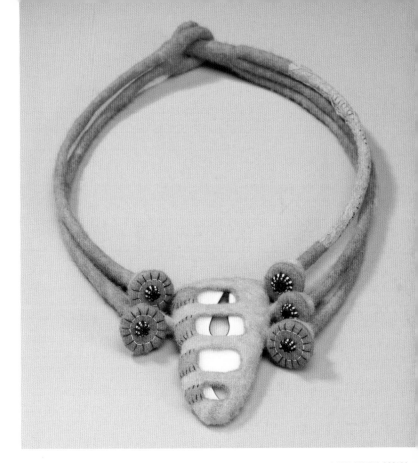

Barbara Cohen

COCOON & FUR PENDANT
14 x 11 x 2.5 cm

Silk cocoons, sterling silver, fox fur, paint; fabricated

PHOTO BY ARTIST

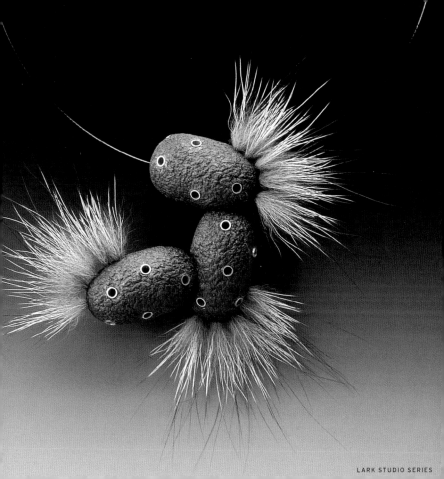

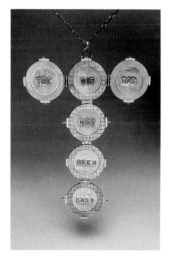
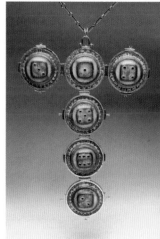

Dana Driver

WITH A LITTLE BIT OF LUCK

5 x 5 x 5 cm

Recycled bottle caps, copper, fine silver, sterling silver,
14-karat gold, patina; embossed, fabricated

PHOTOS BY JON KLEIN AND TAIJI ARITA

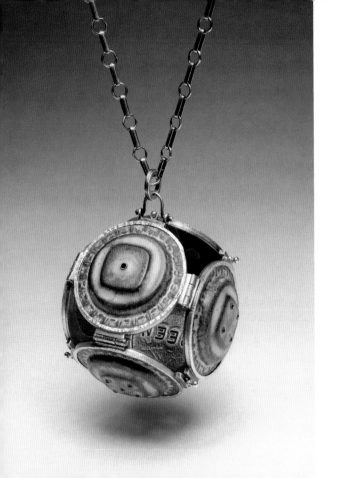

Michelle Pajak-Reynolds

PASSION
Pendant: 7.6 x 8.6 x 1 cm

Amber, pearls, silk, rayon; hand sewed, coiled, knotted

PHOTO BY BRAD RONEVICH, VISCOM COMMERCIAL

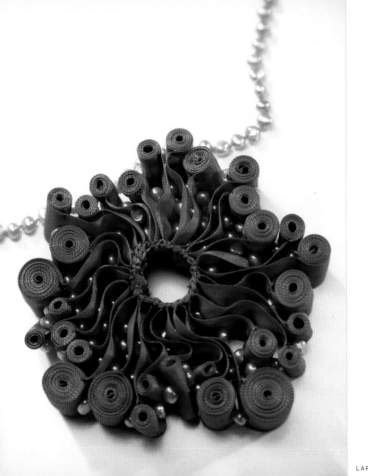

Wendy McAllister

UNTITLED
8.1 x 7 x 1.5 cm

Sterling silver, fine silver, copper mesh,
enamel; hand fabricated, oxidized

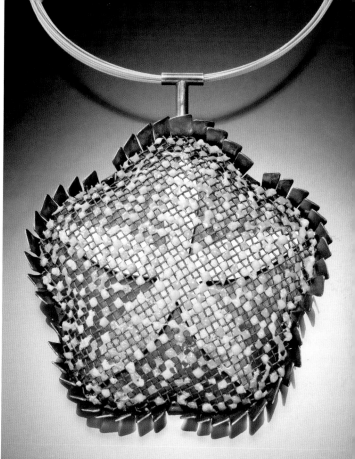

Carol Windsor

AZURE BLOSSOM PENDANT
10 x 7 x 7 cm

Sterling silver, paper; fabricated, laminated

PHOTO BY HAP SAKWA

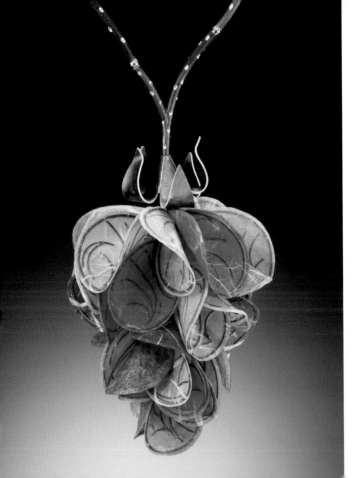

Ramon Puig Cuyàs

TEMPORA SI FUERINT NIBULA
5.5 x 6 x 1 cm

Silver, plastic, nickel silver, wood, volcanic
stones, acrylic paint; assembled

PHOTO BY ARTIST

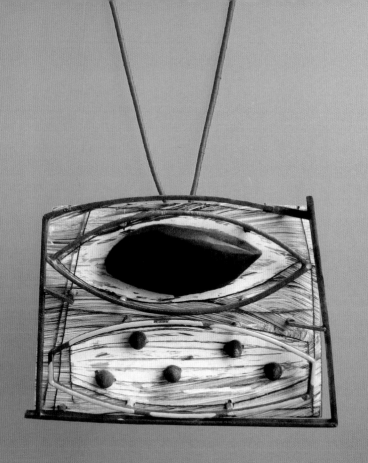

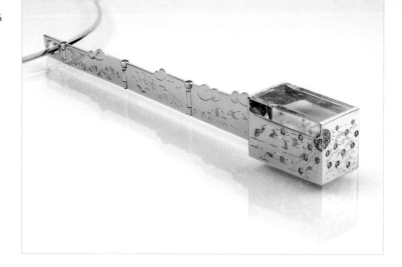

Gunilla Lantz

CLOUDS AND SUN

15.3 x 1.8 x 2.1 cm

18-karat white gold, blue topaz, blue diamonds,
yellow diamonds; engraved

PHOTOS BY SUNE HENNINGSON

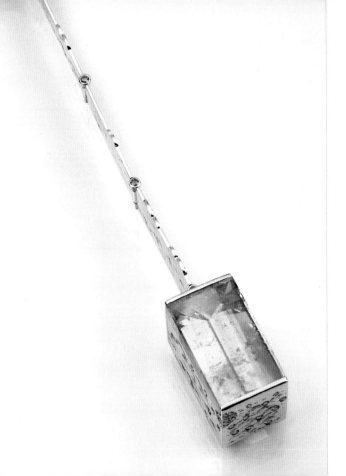

Mayumi Matsuyama

UNTITLED
50 x 20 x 4 cm

Leather

PHOTO BY HIDEYUKI NOMA

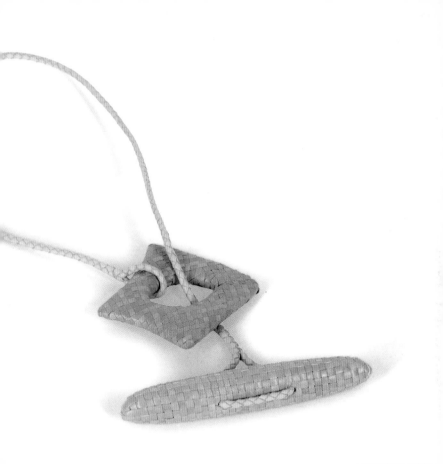

Petra Mandal

BABYCYCLOPS
30 x 10 x 1.5 cm

Serpentine, gold leaf, acrylic, magnet

PHOTO BY EMIL LAHTINEN THUVANDER

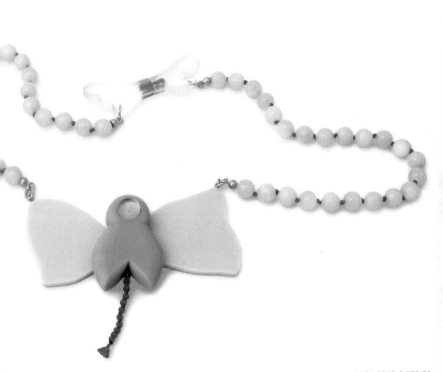

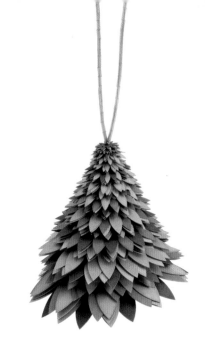

Jennaca Leigh Davies

PAPER PENDANT
10 x 8 x 8 cm

Paper, plastic and steel cording; laser cut

PHOTOS BY STEFFEN KNUDSEN ALLEN

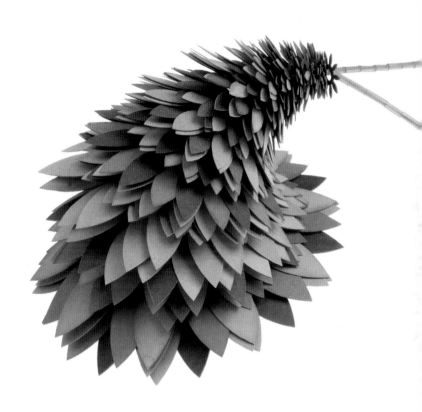

Michal Bar-on Shaish

SEVEN BLUE FLIES
10 x 7 cm

Iron binding wire, enamel, leather; filigree

PHOTO BY LEONID PADRUL

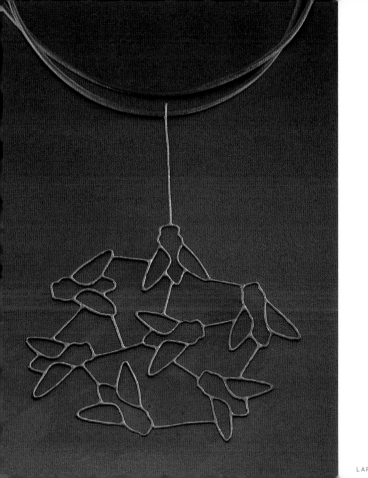

Shauna Mayben Swanson

BIRD CAGE LOCKETS

Each: 3 x 1.8 x 1.5 cm

Silver, patina

PHOTO BY ARTIST

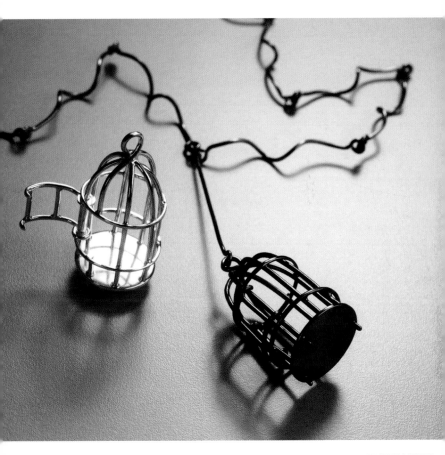

Noriko Hanawa

MANEKINEKO—BECKONING CAT
6 x 3.8 x 0.4 cm

Sterling silver, copper, 18-karat gold, silk cord; oxidized, hand fabricated

PHOTO BY ARTIST

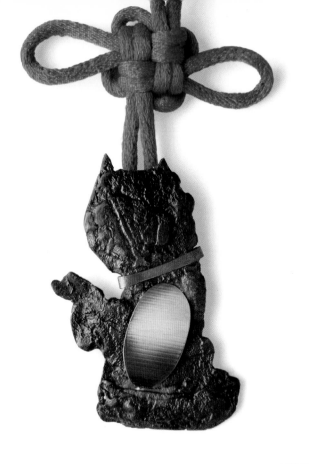

Katherine Ely

BIRD SKULL LOCKET
9.5 x 5.7 cm

Copper, liver of sulfur; raised, repoussé

PHOTO BY CRAIG MCCORMICK

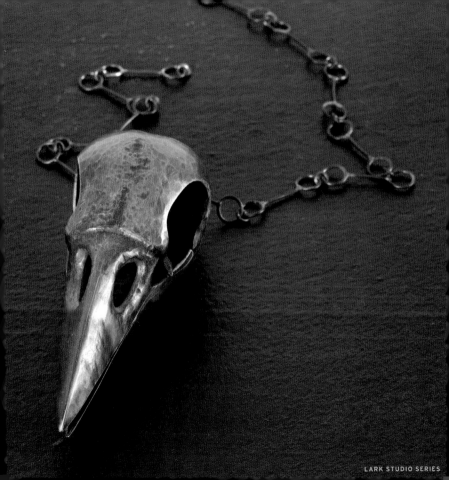

Hratch Babikian

QUEEN URCHIN PENDANT
6 x 6 x 2.5 cm

Mabe pearl, sterling silver, 14-karat gold; carved, cast, fabricated

PHOTO BY ARTIST

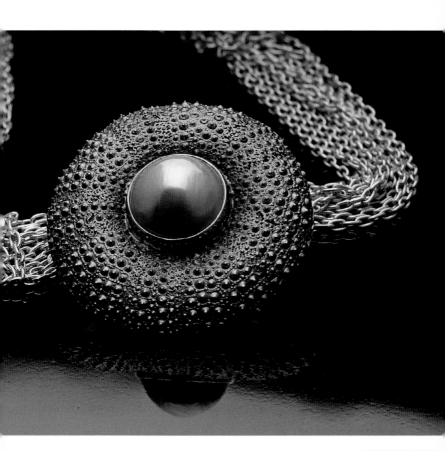

Kathy Buszkiewicz

OMNIA VANITAS XII
5.7 x 5.7 x 1.9 cm

U.S. currency, 14-karat yellow gold, blue zircon; hand fabricated

PHOTO BY ARTIST

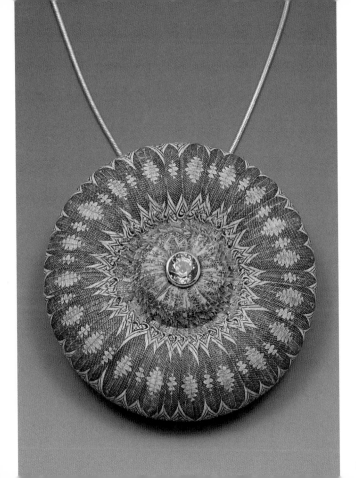

Claudia Costa

EMISSION

8 x 7 x 2.5 cm

Silver, rubber

PHOTO BY ARTIST

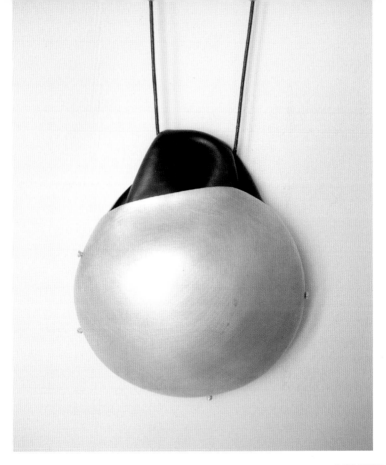

Birgit Laken

BIG THUMBNAIL
2.8 x 7.5 x 2.6 cm

Phenol resin fabric; shaped

PHOTO BY ARTIST

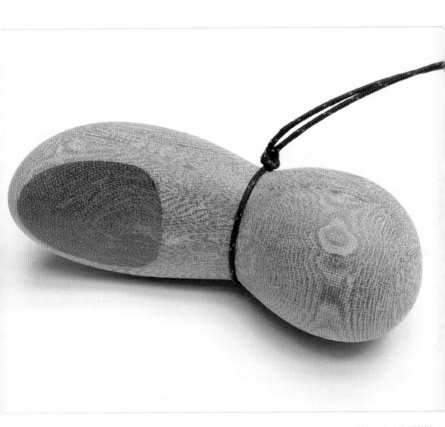

Elizabeth A. White-Pultz

SNOW-TREE

5 x 3 x 0.3 cm

Enamel, copper, 22-karat gold, sterling silver,
moonstone; under fired, bezel set

PHOTO BY D. JAMES DEE

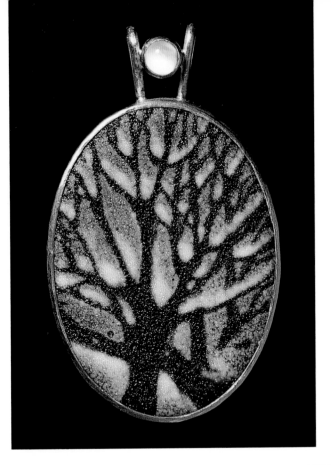

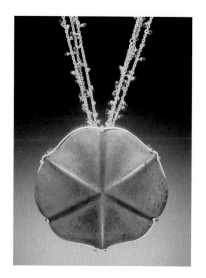

Tricia Lachowiec

FECUND
4.5 x 3.8 x 1.3 cm

Sterling silver, fine silver, copper, enamel, resin; electroformed

PHOTOS BY DEAN POWELL

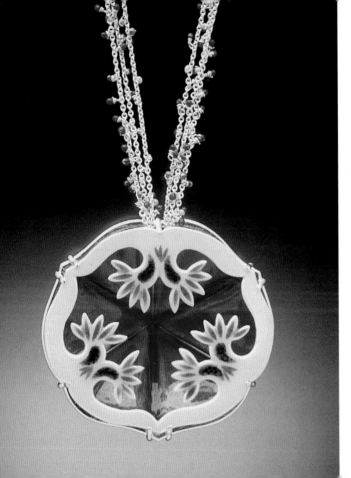

J. L. Collier

SUBMARINER
6.4 x 1.6 x 1.3 cm

Copper, silver, patina; hollow formed, oxidized

PHOTO BY AMY HENDERSON

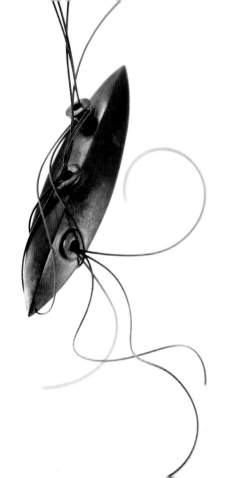

Leslie Matthews

NECKPIECES
Average: 4 x 7 x 8 cm

Sterling silver, silk cord; blackened

PHOTO BY GRANT HANCOCK

Karin Seufert

UNTITLED
9.5 x 5 x 3 cm

PVC, thread, 14-karat gold

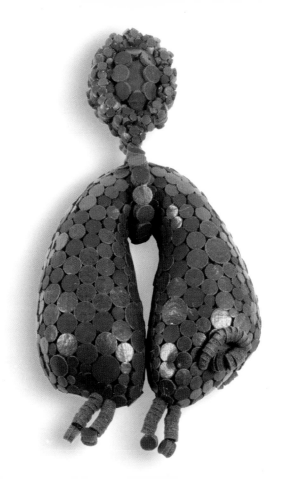

Poly Nikolopoulou

UNTITLED
8.5 x 5.5 x 1 cm

Silver; hammered, constructed

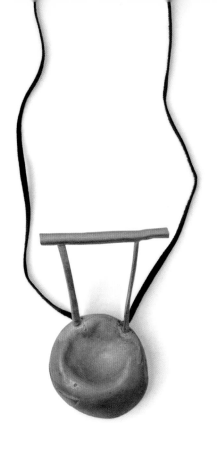

Ellen Burr

CAGED PORCELAIN

4 x 1.5 x 1.5 cm

Sterling silver, porcelain; hand fabricated,
soldered, cold connected

PHOTO BY MARSHA THOMAS

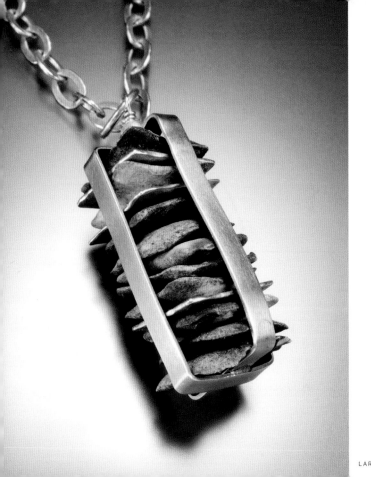

Donald Friedlich

Five star Row

UNTITLED

5 x 8 x 2.3 cm

Glass, diamonds, 18-karat gold, rubber; blown, cold worked, inlaid

PHOTO BY JAMES BEARDS

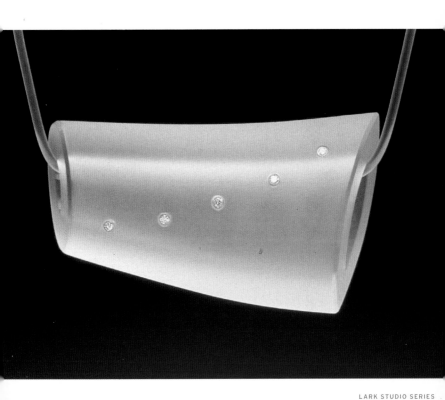

Ingeborg Vandamme

POETRY CONTAINER

Pendant: 2.5 x 10.5 cm

Copper, paper; etched

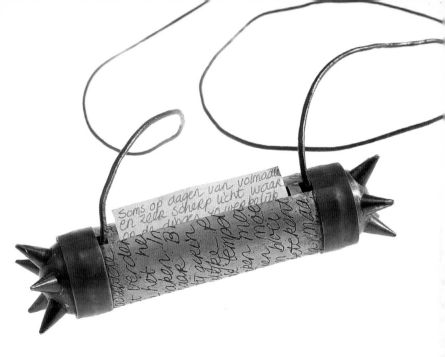

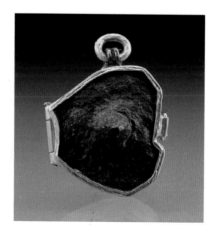

Rob Jackson

AMULET

2.5 x 2 x 1 cm

Found steel, 18-karat gold, 22-karat gold,
uncut rubies; cast, fabricated, hinged, bezel set

PHOTOS BY ARTIST

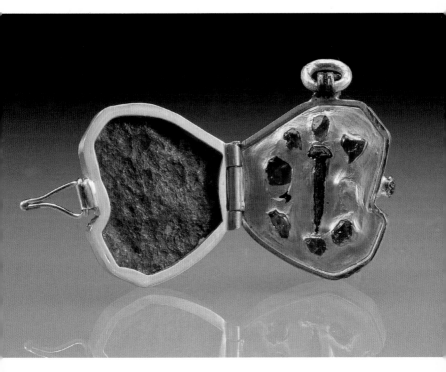

Beth M. Biggs

ROSE

28 x 7 x 1 cm

Copper, enamel, sterling silver; chased, repoussé

PHOTO BY ROGER SMITH

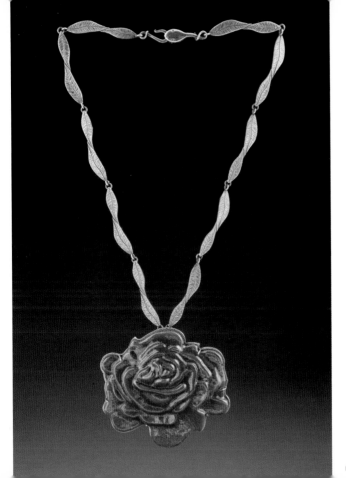

Kathleen R. Prindiville

HIPPO

3 x 4 x 1 cm

Sterling silver, white bronze, patina; cast, molded

PHOTO BY MARTY DOYLE

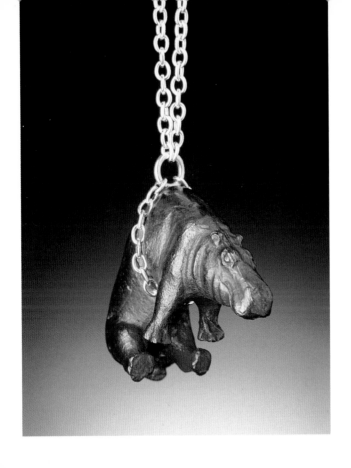

Suzanne Otwell-Nègre

SMALL GOLD AND SILVER STRATA PENDANT

2.3 x 2.3 x 0.7 cm

Bimetal, sterling silver; cut, roller printed, soldered

PHOTO BY FRÉDÉRIC JAULMES

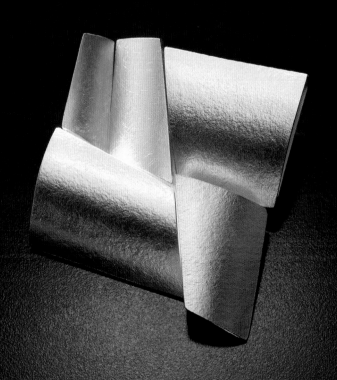

Pavel Herynek

RENAISSANCE IV
3.9 x 2.2 x 2.2 cm

Gilded brass, lace

PHOTO BY ARTIST

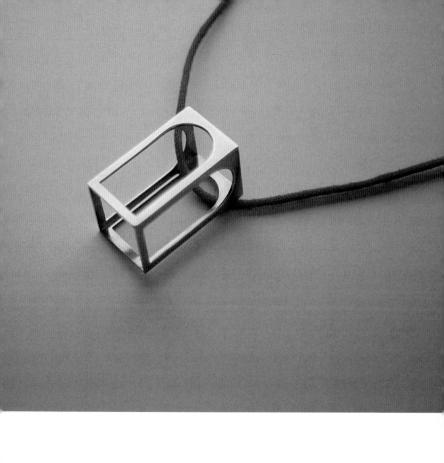

Yeonkyung Kim

PENDANT AND JEWEL CASE

Pendant: 2.7 x 2.7 x 1.1 cm
Case: 2.9 x 2.9 x 4.2 cm

Lemon citrine, rock crystal, 18-karat-gold-plated
sterling silver; rough stone cut

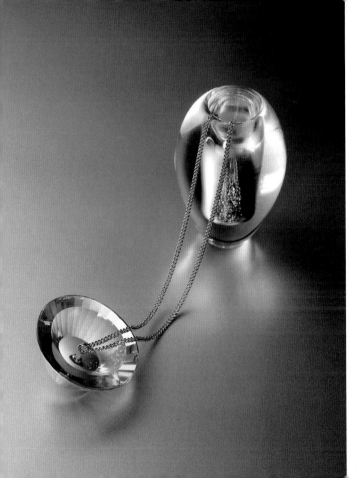

Kelly Nedderman

UNTITLED

10.2 x 9.5 x 1.3 cm

Sterling silver, handmade silk-screened paper,
vintage eyeglass lenses; oxidized

PHOTO BY ADRIAN ORDEÑANA

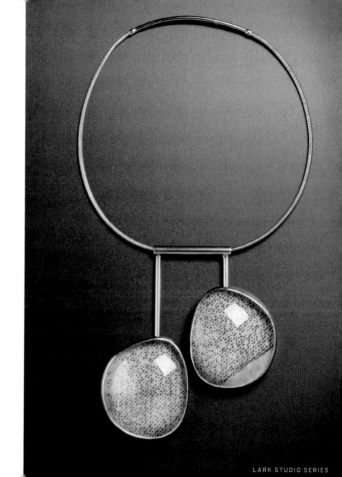

Claire Wolfstirn

HERBES FOLLES
4.2 x 4.2 x 1 cm

Silver, cotton

PHOTO BY GILLES COHEN

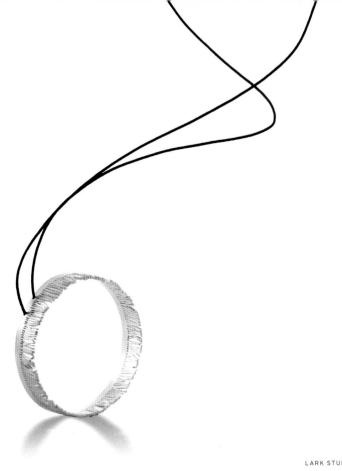

Yael Friedman

PENDANTRICK
3.5 x 3.5 x 1.2 cm

Sterling silver

PHOTOS BY ARTIST

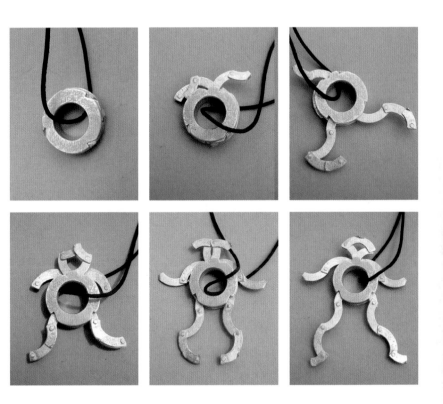

Heidi BigKnife

FROM THE REMEMBERING SERIES
4.2 x 3.2 x 1.2 cm

Sterling silver, 18-karat gold, river rock;
soldered, cuttlefish cast, bezel set

PHOTO BY MARK TORRANCE, BW STUDIOS

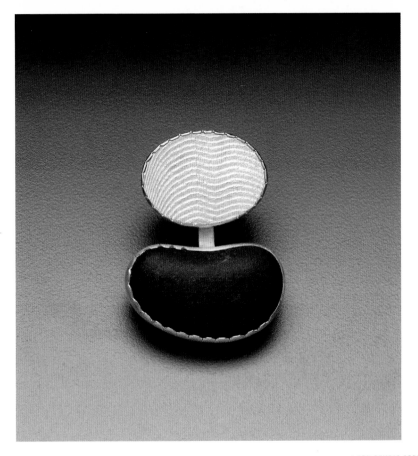

Kirsten Clausager

LAMELLA PENDANTS

3 x 3 x 1.5 cm

Sterling silver, nylon string; hand fabricated,
bent, soldered, rolled

PHOTO BY OLE AKHOJ

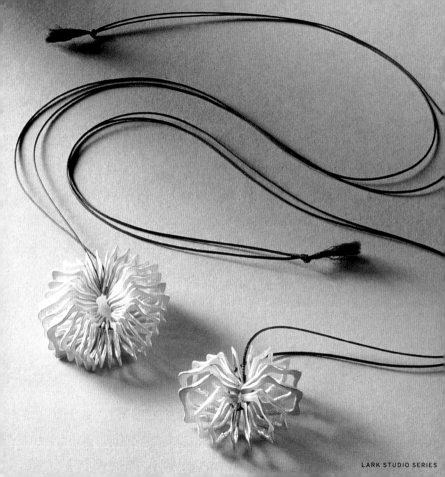

Anette Rack

MOVABLE PENDANT

6 x 6 x 6 cm

Fine silver; electroformed

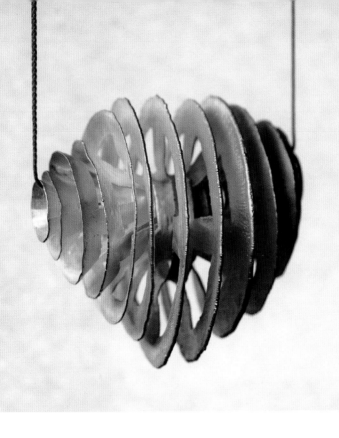

Margarida Amaral

UNTITLED

3 x 3 x 1 cm

Silver, paper

PHOTO BY ALBANE CHOTARD

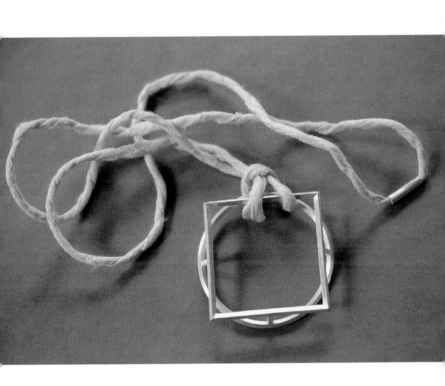

Jorge A. Castañón

MECANO I

5.2 x 6.7 x 0.3 cm

Sterling silver, 24-karat gold, 18-karat gold, shibuishi,
shakudo, nickel silver, copper; constructed, niello

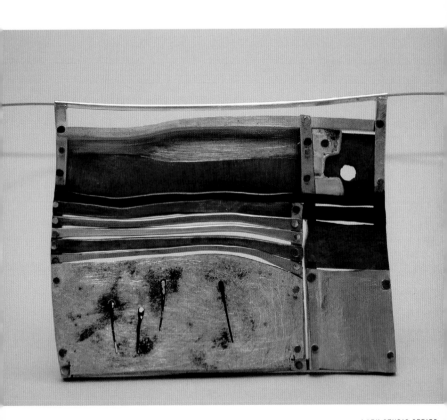

Sungho Cho

NATIVE FIGURE
43 x 8.5 x 0.5 cm

Computer disk, brush, sterling silver, steel wire; sawed, reconstituted

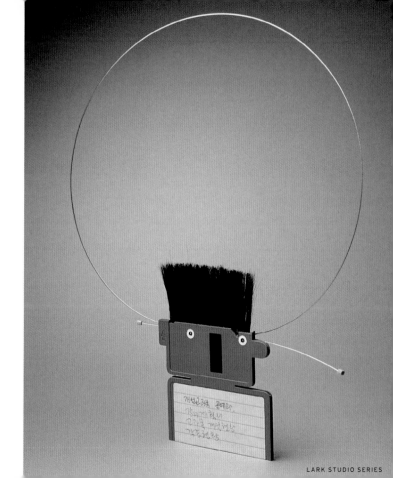

Jacqueline Myers

UNTITLED
2.3 x 1.9 x 0.9 cm

Antique micromosaic, 22-karat gold,
Roman chain; set, hand fabricated

PHOTO BY STANLEY J. MYERS

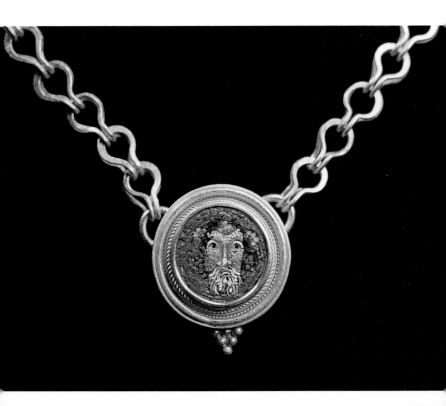

Dina Abargil

WE

51 x 10 x 1.7 cm

Shibuishi, shakudo, ebony, rope

PHOTO BY FEDERICO CAVICCHIOLI

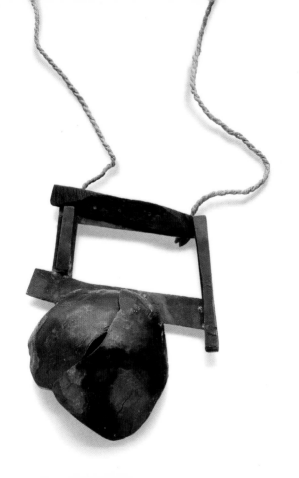

Talya Baharal

URBAN LANDSCAPE #33
8 x 10.8 x 0.3 cm

Sterling silver, iron, steel, copper, gold; fabricated

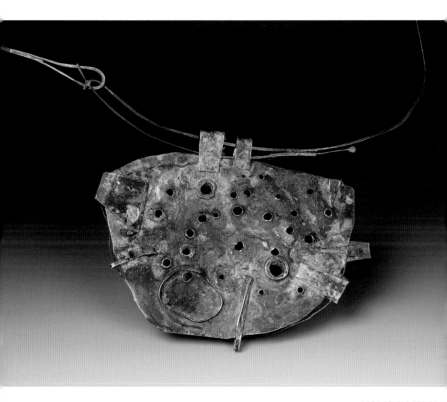

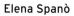

Elena Spanò

UNION
10 x 8.5 x 1 cm

Acrylic sheet, 18-karat gold

PHOTO BY FEDERICO CAVICCHIOLI

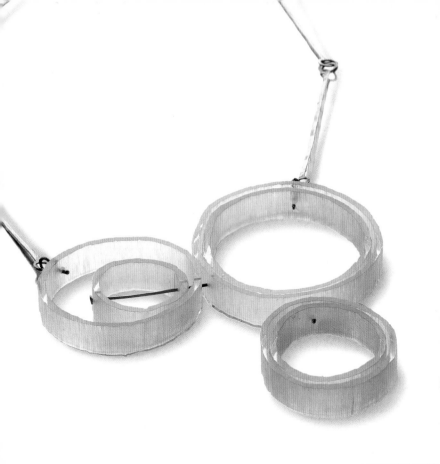

Leonor Hipólito

IN-CORPORATION (#28)
36 x 9.3 x 1.1 cm

Silver, fabric

PHOTO BY ARTIST

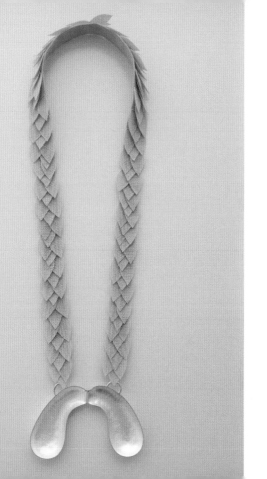

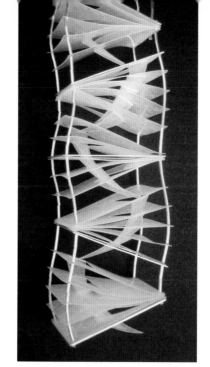

Yuka Saito

UNTITLED
46 x 18 x 3 cm

Sterling silver, polypropylene

PHOTOS BY ARTIST

Paper Ladder

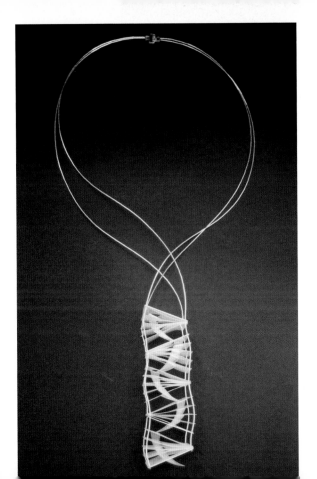

Aliyah Gold

PORTRAIT OF A GIRL
7.6 x 5.1 x 1.3 cm

14-karat gold, branded leather; leather worked, fabricated

PHOTO BY KEN YANOVIAK

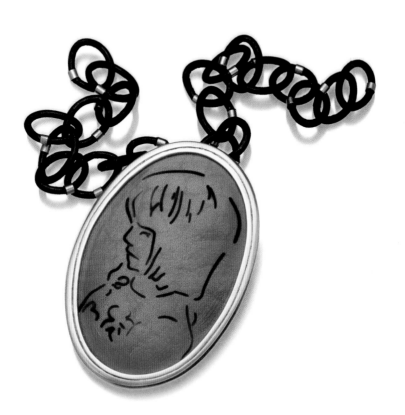

Carmen Amador

BONJOUR MONSIEUR CÉZANNE

1.5 x 4.2 x 1.1 cm

Silver, reconstructed coral, magnetite,
stainless steel cable; chased, constructed

PHOTO BY EUGENIA ORTIZ

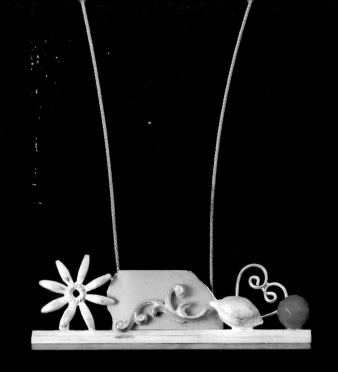

Alice Sprintzen

DIANE
35.6 x 8.3 cm

Found wire, key, sterling silver, glass beads, netting

PHOTO BY DOUGLAS FOULKE

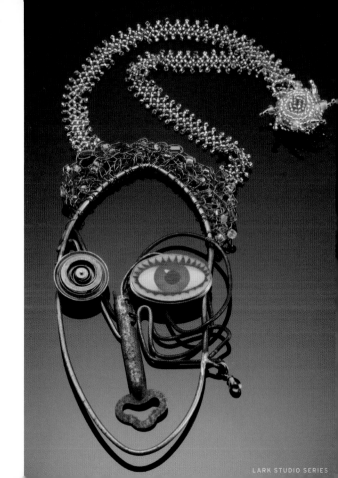

Dennis Nahabetian

SILVER FIGURE PENDANT

7 x 3.8 x 0.8 cm

Bronze, copper, silver plating, sterling silver;
hand fabricated, textile techniques

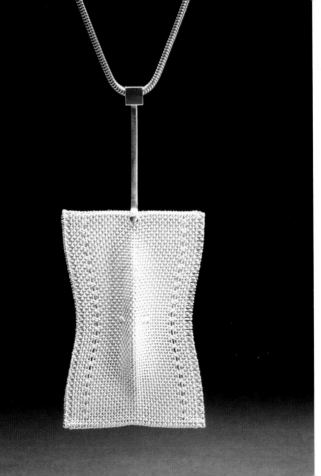

Rebecca Strzelec

IRAN (FROM ARMY GREEN LAUNDRY)
14.7 x 16.5 x 4.5 cm

ABS plastic, cord; fused deposition modeled

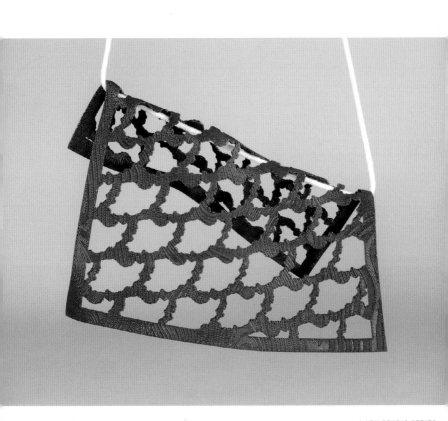

Judy McCaig

BENEATH THE CLOUDS
3.2 x 5.5 x 0.3 cm

Silver, 18-karat gold, rock crystal, Perspex,
gold leaf, paint; constructed, lost wax cast

PHOTO BY EUGENIA ORTIZ

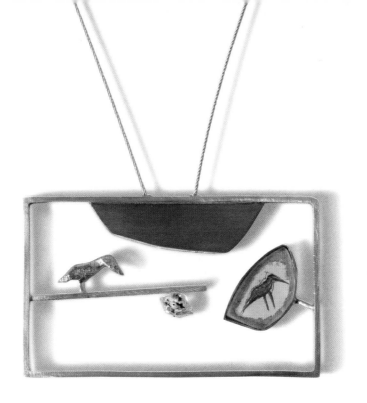

ARTIST INDEX

Enjoy more of the books in the
LARK STUDIO SERIES

Art Tiles

Handmade Books

Chairs

Pendants